This book belongs to:

MaKena

Malaro

DOODLING FOR
TREE HUGGERS
& NATURE LOVERS

by Gemma Correll

Quarto is the authority on a wide range of topics.
Quarto educates, entertains and enriches the lives of our readers—
enthusiasts and lovers of hands-on living.
www.quartoknows.com

Illustrated and written by Gemma Correll
Select text by Stephanie Carbajal

6 Orchard Road, Suite 100
Lake Forest, CA 92630
quartoknows.com
Visit our blogs @quartoknows.com

Printed in China
3 5 7 10 9 8 6 4 2

TABLE OF CONTENTS

HOW TO USE THIS BOOK

This book is just a guide. Each artist
has his or her own style. Using your imagination
will make the drawings more unique and special!
The fun of doodling comes from not trying too hard.
So don't worry about making mistakes or trying
to achieve perfection.

Here are some tips to help you get the
most of this doodling book.

DOODLE PROMPTS

The prompts in this book are designed to get your creative juices
flowing—and your pen and pencil moving! Don't think too much about
the prompts; just start drawing and see where your imagination takes
you. There's no such thing as a mistake in doodling!

STEP-BY-STEP EXERCISES

Following the step-by-step exercises is fun and easy! The red lines
show you the next step. The black lines are the steps you've already
completed.

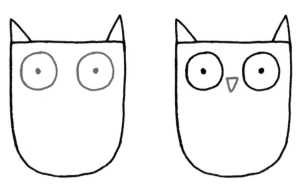

SUPPLIES

Doodling doesn't require any special tools or materials. You can draw with anything you like! Here are a few of my favorite drawing tools.

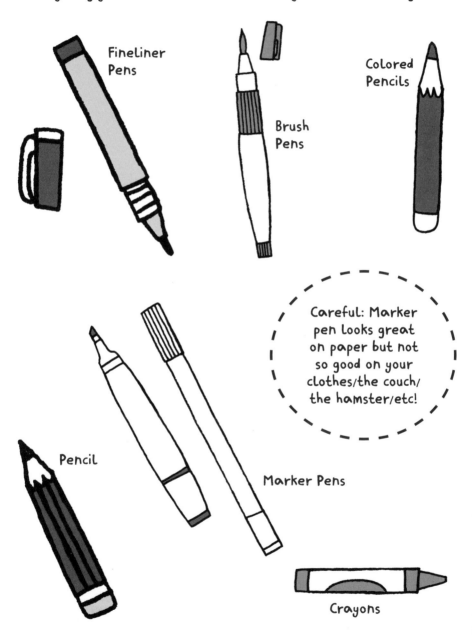

Fineliner Pens

Brush Pens

Colored Pencils

Careful: Marker pen looks great on paper but not so good on your clothes/the couch/ the hamster/etc!

Pencil

Marker Pens

Crayons

20 SIGNS YOU'RE A NATURE LOVER

1. Your favorite form of exercise is biking. Or canoeing. Or skiing. It's hard to decide—you love it all!

2. You hoard recyclables until you find an appropriate receptacle for them.

3. The trunk of your car is filled with reusable bags.

4. You always have an emergency stash of granola on hand.

5. If it comes in bamboo, you'll take it—sustainable is your middle name!

6. Your favorite place to shop is the local outdoor-equipment store.

7. The park rangers at the closest state park know you by name.

8. Unwanted insects in your home get a trip to the backyard instead of a date with death.

9. You drive a hybrid vehicle.

10. Your dream home is an open, airy, solar-powered cabin surrounded by trees.

11. When your friends and family can't find you, they assume you're communing with nature.

12. Your bookshelf is filled with nature guidebooks.

13. Your travel bucket list is based on the natural wonders of the world.

14. You've named your pets after types of plants and trees. "Here, Cedar!"

15. Hiking is your preferred form of therapy.

16. You can name at least 20 types of trees off the top of your head.

17. Your email address is naturelover@ilove trees.com.

18. One of your favorite pastimes is walking barefoot in the grass.

19. Your favorite holiday is Earth Day.

20. You have literally hugged at least one tree.

DRAW A PICTURE OF YOUR FAVORITE TREE OR WOODLAND CREATURE IN THE FRAME.

Woodsy Wonderful You

Favorite place to hike:

Favorite kind of granola:

Favorite outdoor activity:

Favorite state or national park:

Favorite outdoor oasis:

NATURE QUIZ

Can you match these wow-worthy parks and natural wonders to their location? Give it a try, and check your answers on the bottom of page 11!

_____1. Yosemite National Park

_____2. Grand Teton National Park

_____3. Etosha National Park

_____4. Lake Hillier

_____5. Iguazú Falls

_____6. Banff National Park

_____7. Verdon Gorge

_____8. Snowdonia National Park

_____9. Los Roques Archipelago

_____10. Fiordland National Park

A. Middle Island, Western Australia

B. Alberta, Canada

C. Montana, USA

D. Provence, France

E. Wales, UK

F. California, USA

G. Venezuela, South America

H. Namibia, Africa

I. Argentina & Brazil, South America

J. New Zealand

OUTDOOR ESSENTIALS

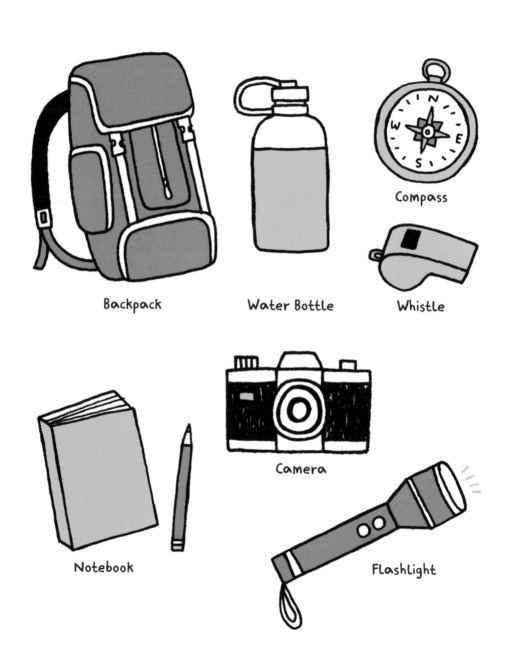

Backpack

Water Bottle

Compass

Whistle

Camera

Notebook

Flashlight

FIRST AID

Sunscreen

Bug Spray

Hand Sanitizer

Bandages

Safety Pins

Cotton Balls
and Swabs

Painkillers

Tweezers

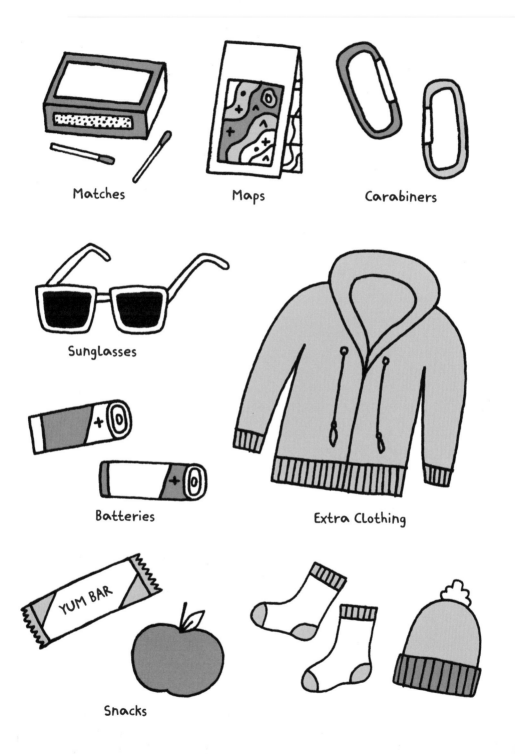

Matches

Maps

Carabiners

Sunglasses

Batteries

Extra Clothing

YUM BAR

Snacks

SWISS ARMY KNIFE

A Swiss Army knife contains various tools. The largest ever made, "The Giant," has 87!

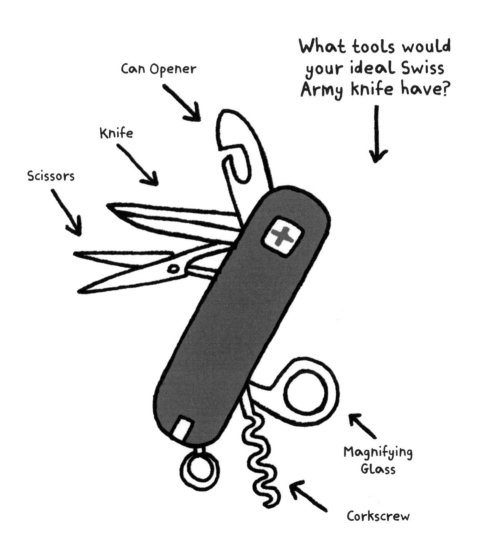

Can Opener

Knife

Scissors

What tools would your ideal Swiss Army knife have?

Magnifying Glass

Corkscrew

WHAT'S IN YOUR BACKPACK?

Design a backpack that you'd love to
carry in the great outdoors.

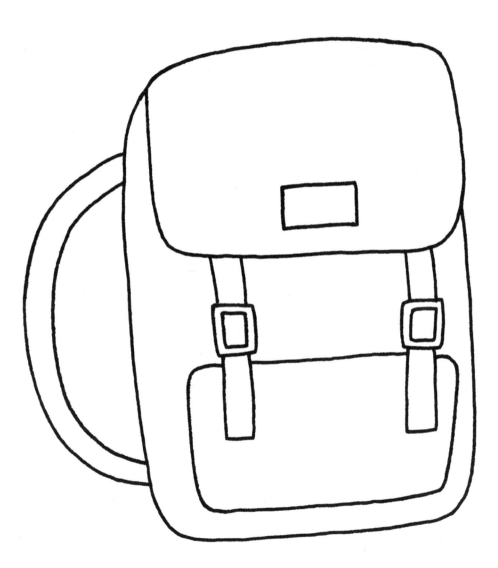

What do you have in your backpack?

TYPES OF TENTS

POP-UP TENT
Lightweight, easy-to-erect
tent in a dome or tunnel
shape, usually made
of nylon.

RIDGE TENT
The classic tent shape,
held up by a pole at each end
(and sometimes, a cross pole
to hold up the roof).

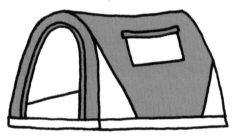

TIPI
Conical tent, traditionally
made with wooden poles
and animal skins.

BELL TENT
Simple canvas tent,
supported by one
central pole.

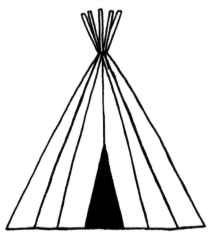

INSIDE YOUR TENT

A few things you might need...

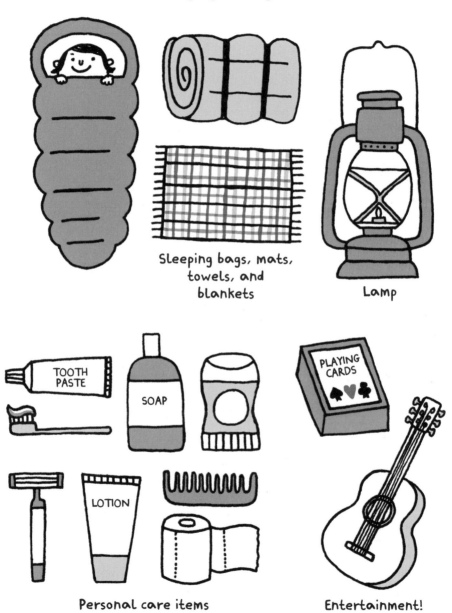

Sleeping bags, mats, towels, and blankets

Lamp

Personal care items

Entertainment!

OUTDOOR CLOTHING
FOR COLD WEATHER

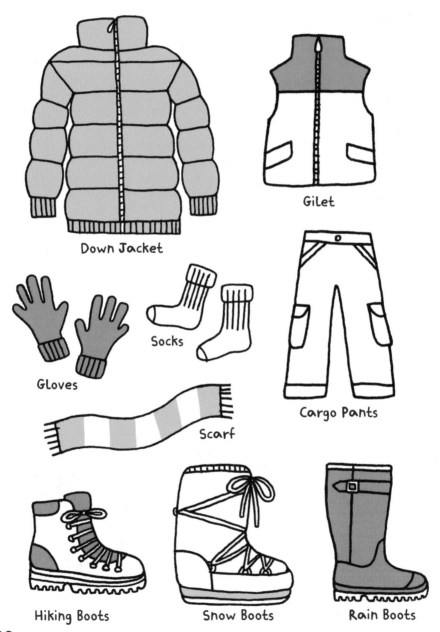

Down Jacket

Gilet

Gloves

Socks

Scarf

Cargo Pants

Hiking Boots

Snow Boots

Rain Boots

FOR THE BEACH & SWIMMING HOLE

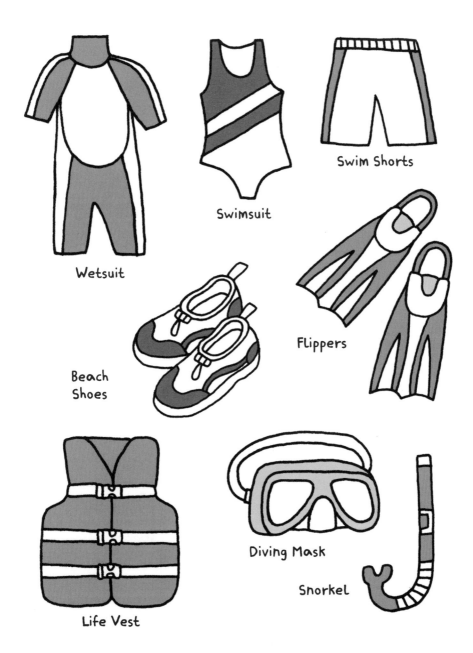

Wetsuit

Swimsuit

Swim Shorts

Beach Shoes

Flippers

Life Vest

Diving Mask

Snorkel

SNOW GEAR

Design some ski and snowboard gear
that you'd love to wear on the slopes.

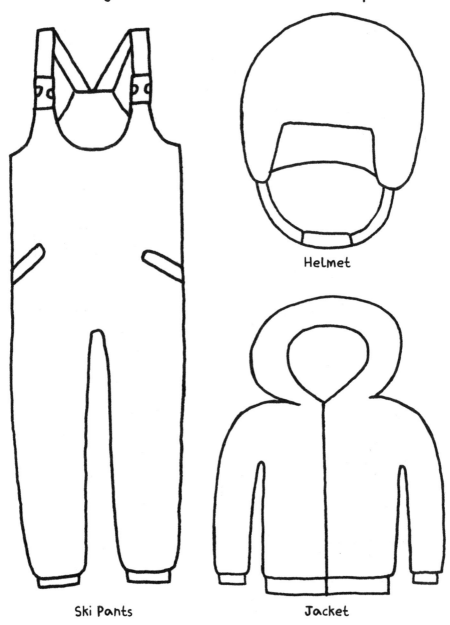

Helmet

Ski Pants

Jacket

DESIGN A SNOWBOARD

Design an awesome snowboard to do some awesome tricks* on.

Doodle an all-over pattern or a cool logo.

*Q: Here are some snowboard trick names. One of them is fake. Can you guess which?

POPTART
ROAST BEEF
CANNONBALL
PORK SAUSAGE
SQUIRREL
KOREAN BACON

*A: PORK SAUSAGE

DRAW A TERRIFIC TENT

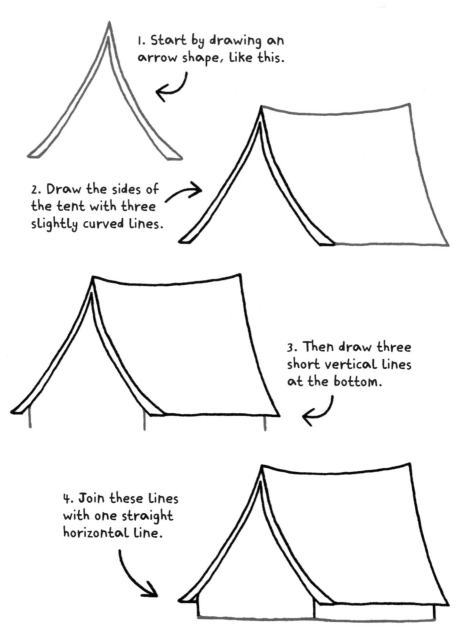

1. Start by drawing an arrow shape, like this.

2. Draw the sides of the tent with three slightly curved lines.

3. Then draw three short vertical lines at the bottom.

4. Join these lines with one straight horizontal line.

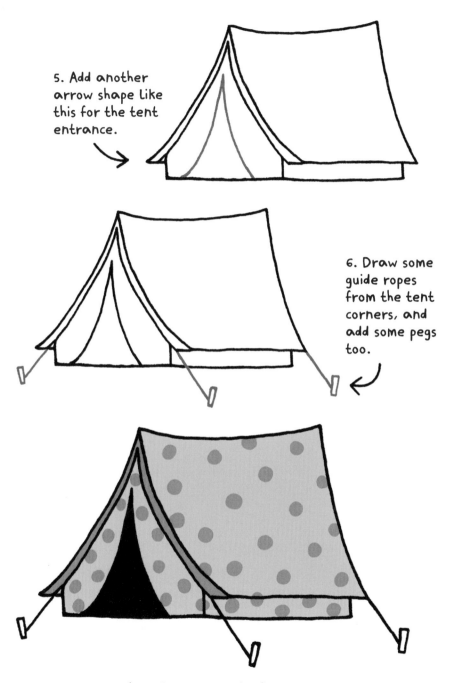

5. Add another arrow shape like this for the tent entrance.

6. Draw some guide ropes from the tent corners, and add some pegs too.

That's it! Don't forget to decorate your tent.

Draw your terrific tent here!

26

TREES & PLANTS

TREE LEAVES

Oak

Elm

Ginkgo

Magnolia

Horse Chestnut

Beech

Cottonwood

Ash

Sycamore

Juniper

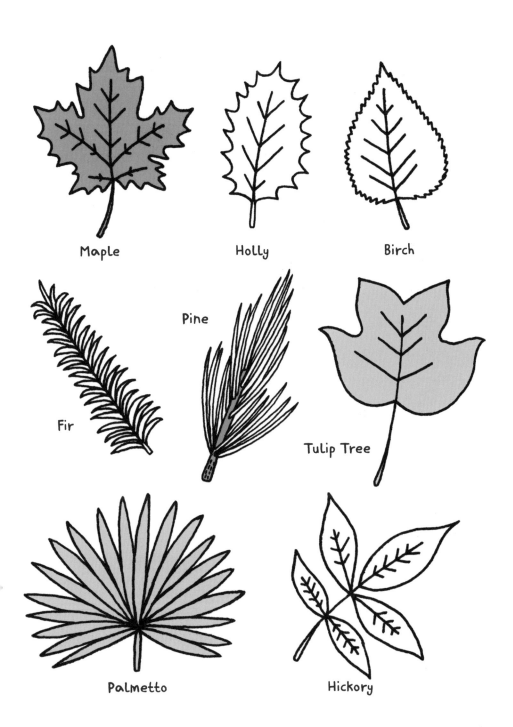

Maple

Holly

Birch

Fir

Pine

Tulip Tree

Palmetto

Hickory

PINECONES

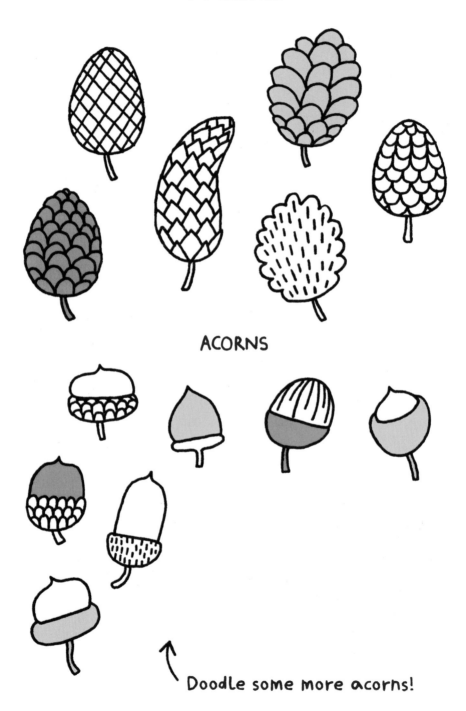

ACORNS

Doodle some more acorns!

MUSHROOMS AND FUNGI

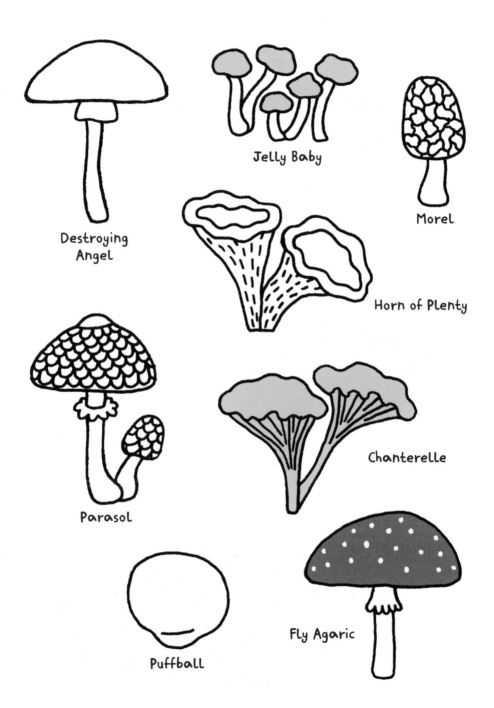

Destroying Angel

Jelly Baby

Morel

Horn of Plenty

Parasol

Chanterelle

Puffball

Fly Agaric

LEAFY DOODLES

Use real leaves to create fun doodles.

Your turn!

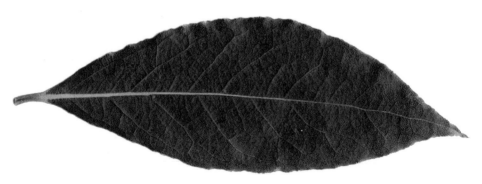

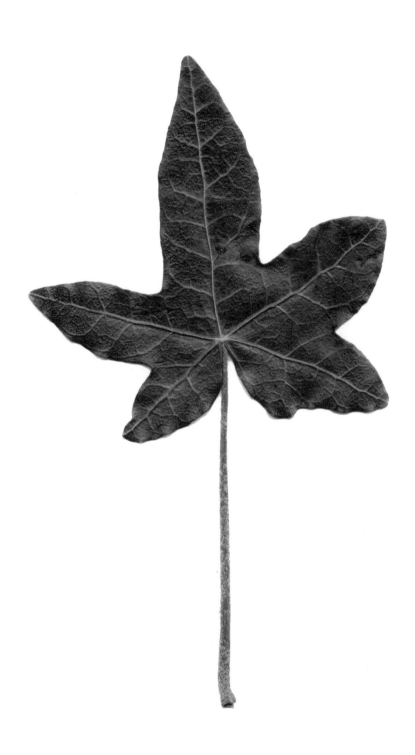

DRAW TERRIFIC TREES

You can draw basic tree shapes by first drawing
a long rectangle and then adding another simple
shape on top.

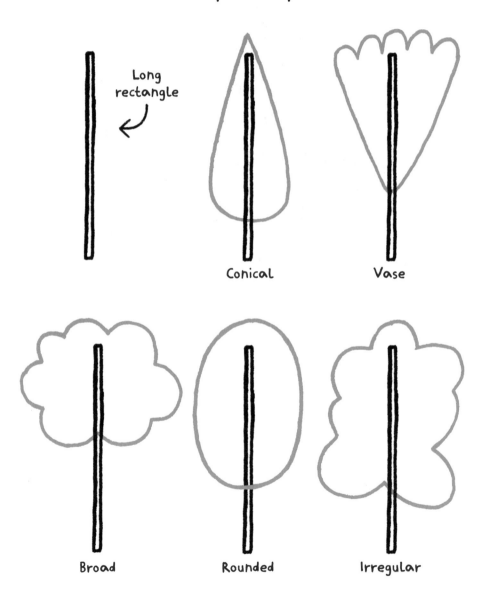

Long
rectangle

Conical

Vase

Broad

Rounded

Irregular

DRAW A PERKY PYRAMIDAL TREE

1. Start by drawing a long rectangle shape for the trunk.

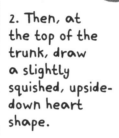

2. Then, at the top of the trunk, draw a slightly squished, upside-down heart shape.

3. Add another slightly wider, squished, upside-down heart underneath the first.

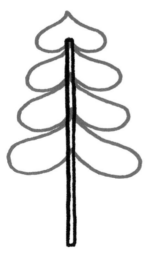

4. Keep adding squished upside-down hearts, making each one a little wider than the previous.

5. Well done! Now color your tree.

Draw your perky tree here!

37

DESERT LIFE
CACTI

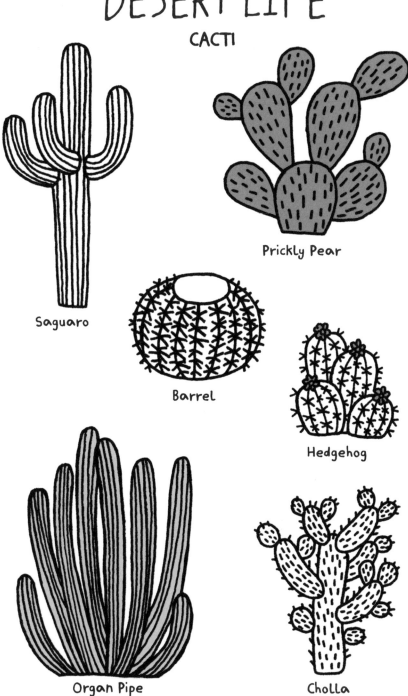

Saguaro

Prickly Pear

Barrel

Hedgehog

Organ Pipe

Cholla

OTHER DESERT PLANTS

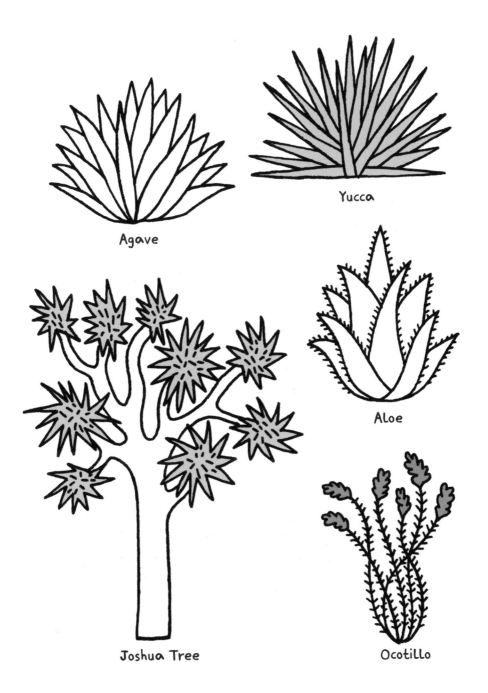

Agave

Yucca

Aloe

Joshua Tree

Ocotillo

DESERT REPTILES

LIZARDS

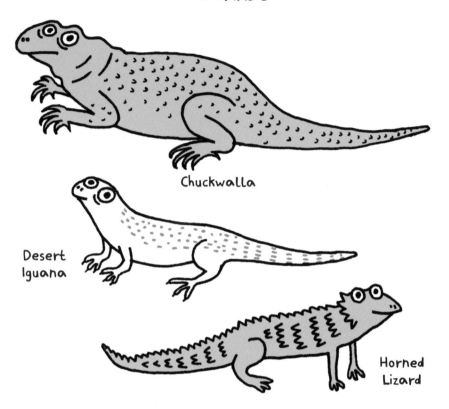

Chuckwalla

Desert
Iguana

Horned
Lizard

TURTLES

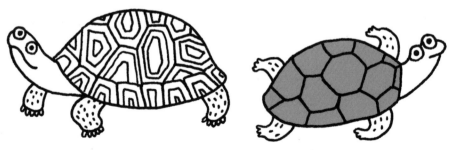

Desert Tortoise

Western Pond Turtle

S-S-S-SNAKES

Snakes exist on every continent except Antarctica.
These are just a few of more than 3,000 species.

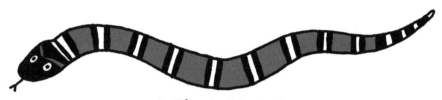

California Kingsnake

Western Shovel-nosed Snake

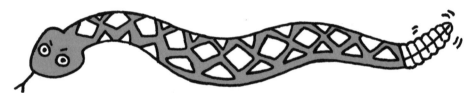

Diamondback Rattlesnake

Black Rat Snake

Arizona Coral Snake

DESIGN-A-SNAKE

Invent your own snake breeds! Doodle cool markings on these snakes and give them one-of-a-kind names. Here are a few ideas to get you started.

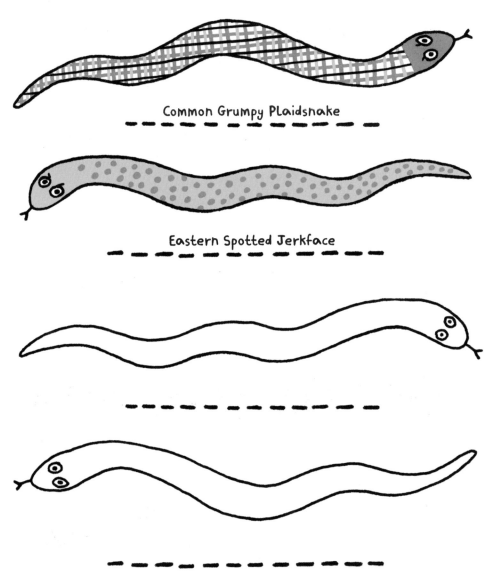

Common Grumpy Plaidsnake

- - - - - - - - - - - - - - - - - -

Eastern Spotted Jerkface

- - - - - - - - - - - - - - - - - -

- - - - - - - - - - - - - - - -

- - - - - - - - - - - - - - - - -

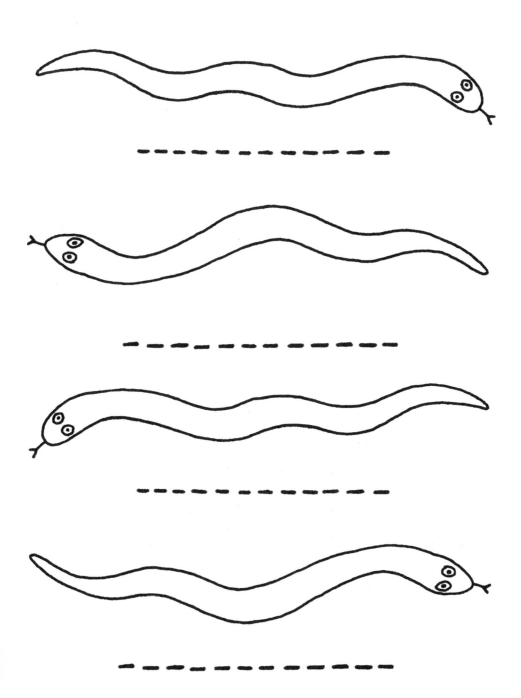

DRAW A SUPER SAGUARO CACTUS

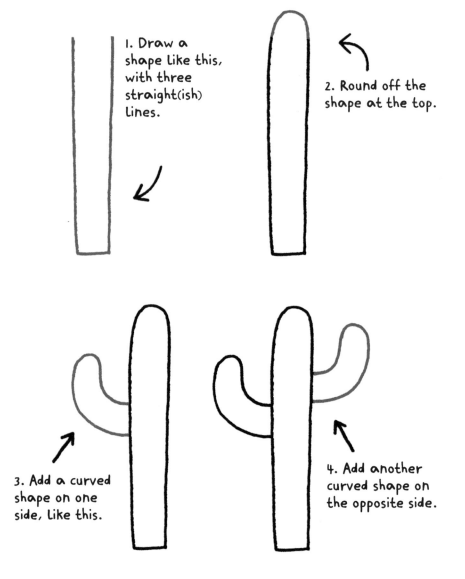

1. Draw a shape like this, with three straight(ish) lines.

2. Round off the shape at the top.

3. Add a curved shape on one side, like this.

4. Add another curved shape on the opposite side.

44

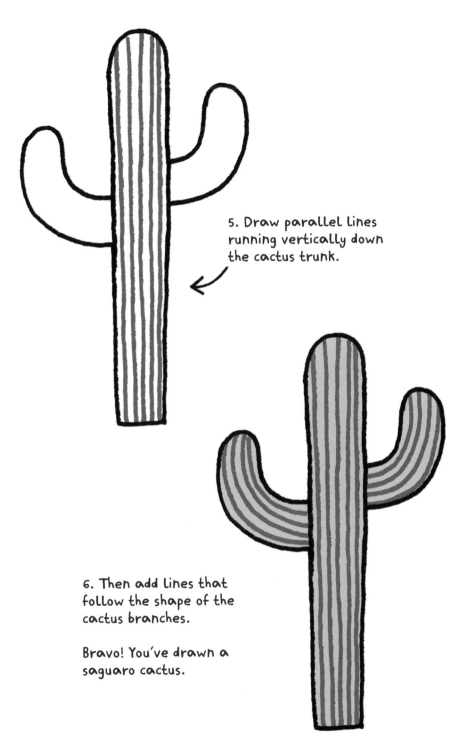

5. Draw parallel lines running vertically down the cactus trunk.

6. Then add lines that follow the shape of the cactus branches.

Bravo! You've drawn a saguaro cactus.

Draw your super saguaro cactus here!

CLASSIC CAMPING FOODS

Some tasty treats to eat around the campfire.

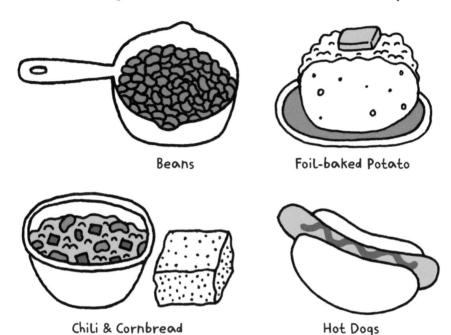

Beans

Foil-baked Potato

Chili & Cornbread

Hot Dogs

...and for dessert

S'mores

Foil-baked Peaches
with Berries &
Chocolate

Toffee Apples

CAMPING COOKWARE

Some useful things to take with you on a camping trip or Long hike.

Pots & Skillets

Plates, Bowls & Cutlery

Coffeepot & Mugs

Cooler Bag
(for perishables)

Camping Stove

Trash Bags
(for cleaning up)

TRAIL MIX

Trail mix is a classic outdoor snack food.
These are some popular trail mix ingredients:

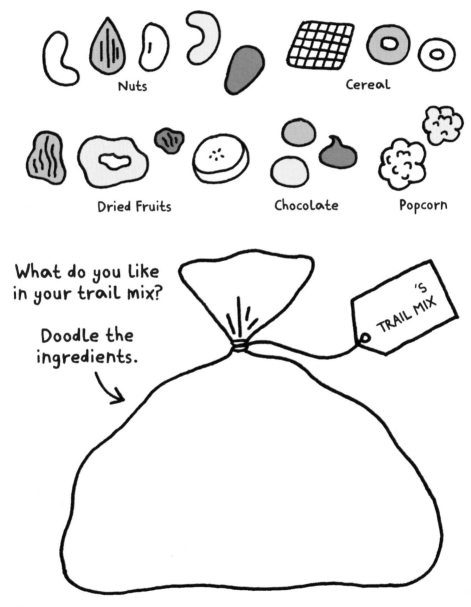

Nuts

Cereal

Dried Fruits

Chocolate

Popcorn

What do you like in your trail mix?

Doodle the ingredients.

'S TRAIL MIX

DELIGHTFUL DRINKS

Beverages to keep you warm on a chilly evening.

HOT CHOCOLATE
with mini
marshmallows

APPLE CIDER
with cinnamon, cloves,
and orange peel

MULLED WINE
with cranberry juice
and orange

COCONUT CHAI
Chai tea with coconut
milk and cinnamon

HOW TO MAKE S'MORES

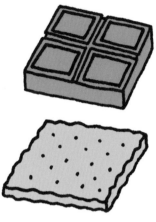

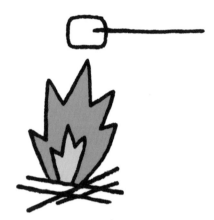

1. Place a block of chocolate on top of a graham cracker.

2. Toast a marshmallow over the campfire.

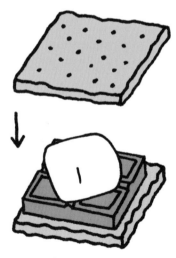

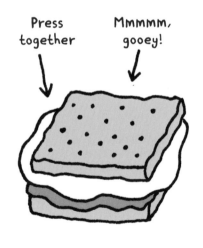

Press together

Mmmmm, gooey!

3. Put the toasted marshmallow on top of the chocolate. Then add another cracker on top.

4. Enjoy your delicious s'more...and make s'more!*

*Fun fact: S'more is short for "some more."

S'MORE S'MORES!

What other fillings would you add to your s'mores? Peanut butter and banana? A different kind of chocolate? Doodle your ideas here.

DRAW A TERRIFICALLY TOASTY CAMPFIRE

1. Start by drawing one log—draw a tube shape, like this, at an angle.

2. Add another log of about the same length underneath, to form a cross shape.

3. Draw a flame shape on top of the logs.

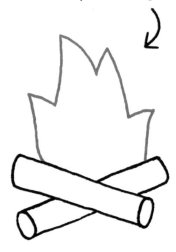

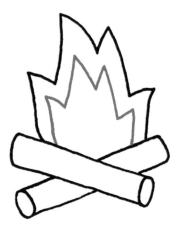

4. Add a second, similar flame shape inside the first.

5. Add one more little flame shape inside the big flames.

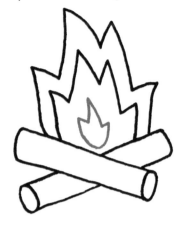

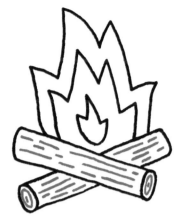

6. Add detail and texture to the logs by drawing lines and circles.

7. Color the flame—remember, the outer flame should be the darkest shade.

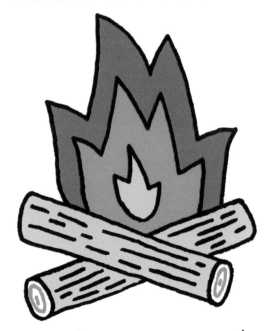

All done! Let's toast some marshmallows!

Draw your toasty campfire here!

57

TAKE A HIKE!

These are just a few of the most beautiful famous hikes around the world.

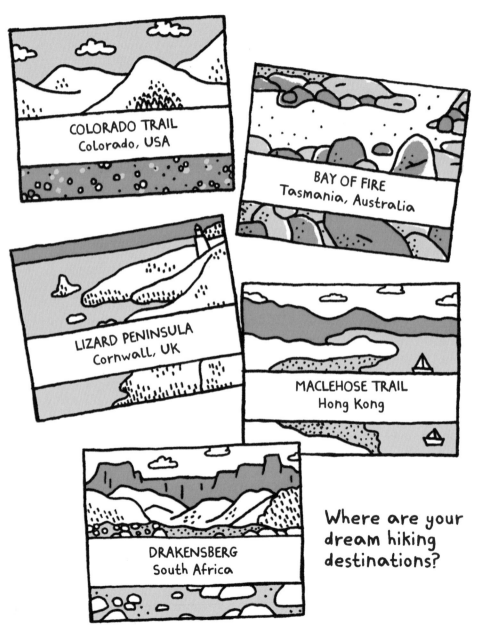

COLORADO TRAIL
Colorado, USA

BAY OF FIRE
Tasmania, Australia

LIZARD PENINSULA
Cornwall, UK

MACLEHOSE TRAIL
Hong Kong

DRAKENSBERG
South Africa

Where are your dream hiking destinations?

Design a postcard from your dream hiking or camping destinations.

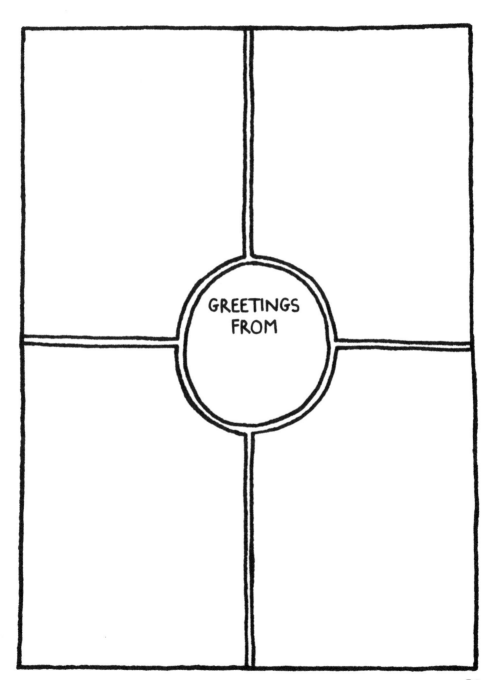

GREETINGS FROM

GREETINGS FROM

60

TRAIL SIGNS

You can make signs for other hikers using readily available materials, such as rocks, twigs, pebbles, and grass.

	STRAIGHT AHEAD	TURN RIGHT	TURN LEFT	DON'T GO THIS WAY
ROCKS				
PEBBLES				
TWIGS				

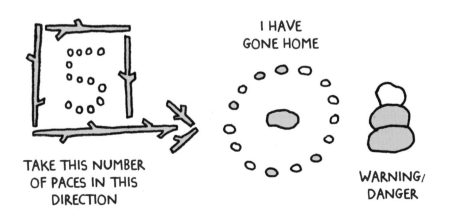

TAKE THIS NUMBER OF PACES IN THIS DIRECTION

I HAVE GONE HOME

WARNING/ DANGER

DOODLE MERIT BADGES

Hiking is hard work! You deserve some merit badges!
Design some for yourself.

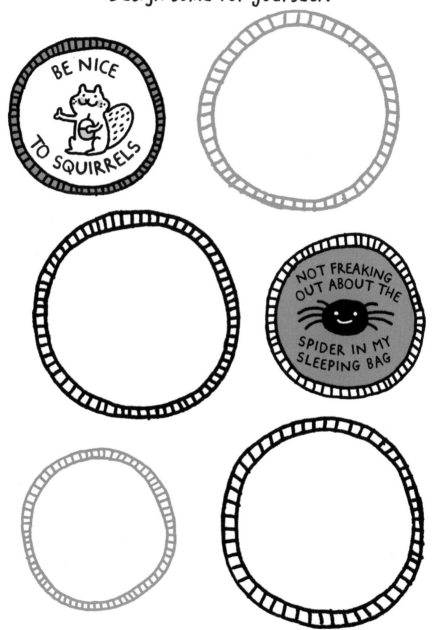

BE NICE
TO SQUIRRELS

NOT FREAKING
OUT ABOUT THE

SPIDER IN MY
SLEEPING BAG

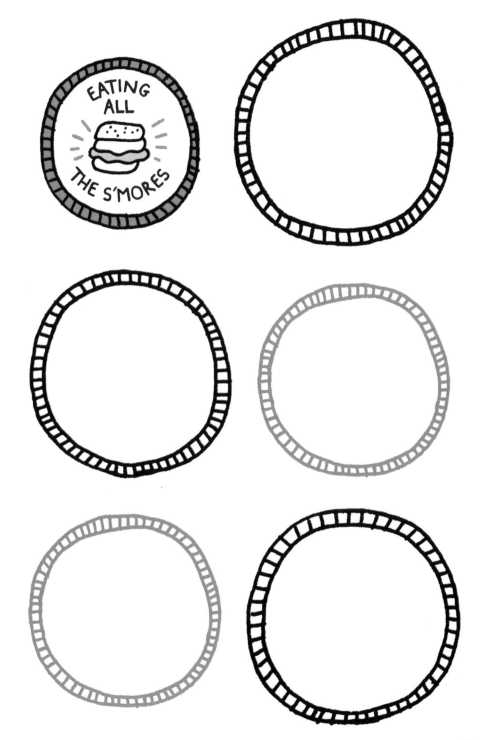

EATING ALL THE S'MORES

DRAW A WHOO-NDERFUL OWL

1. Start by drawing this shape.

2. Then add two triangles at the top for ears.

3. Draw big circles for the eyes.

4. Add a little triangle like this for the beak.

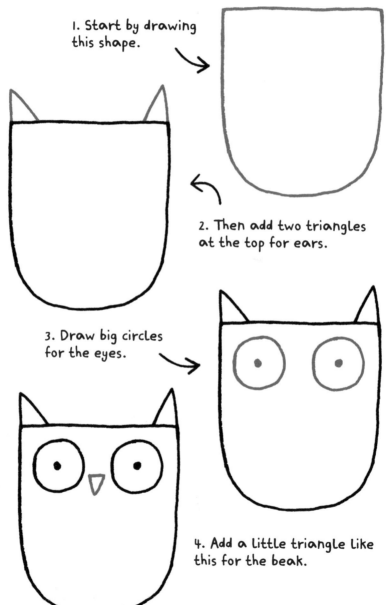

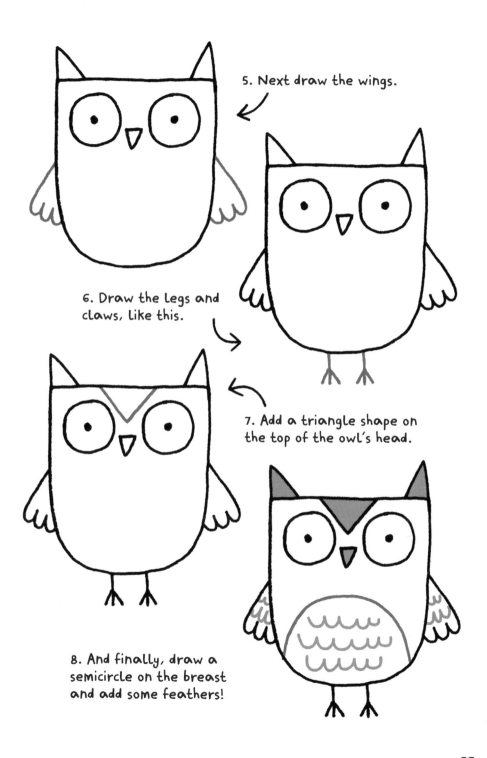

5. Next draw the wings.

6. Draw the legs and claws, like this.

7. Add a triangle shape on the top of the owl's head.

8. And finally, draw a semicircle on the breast and add some feathers!

Draw your whoo-nderful owl here!

FUN OUTDOORSY FACTS

Fact: There are more than 23,000 different kinds of trees in the world.

Fact: A campfire can reach temperatures of more than 900 degrees Fahrenheit after a few hours. Keep that bucket of water handy!

Fact: 85% of plant life is found in the ocean!

Fact: The height of Mount Everest is disputed because of its snow cover.

Fact: Yellowstone National Park (Montana, USA), which opened in 1872, is the world's first national park.

Fact: A mature oak tree can absorb 50 gallons of water in one day—or more on an especially hot day!

Fact: You can determine the temperature outside by counting cricket chirps.

Fact: Spider silk is about five times stronger than steel of the same weight.

Fact: The world's deepest and longest canyon is not the Grand Canyon (Arizona, USA),

but Yarlung Tsangpo Grand Canyon in the Himalayas.

Fact: Bamboo can grow up to 35 inches in a single day!

Fact: Trees are the longest-living organisms on Earth.

Fact: There are more than 30 species of mushroom that glow in the dark, thanks to a chemical reaction that produces a glowing light known as "foxfire."

Fact: Any landmass that rises at least 1,000 feet above the surrounding area is considered a mountain.

Fact: Wrangell-St. Elias National Park and Preserve (Alaska, USA) is the largest national park at a whopping 13.2 million acres!

Fact: Millions of trees grow every year, thanks to our furry squirrel friends forgetting where they hid their nuts!

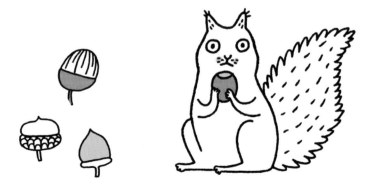

CHARMING CREATURES

Here are a few critters that you might encounter in the great outdoors.

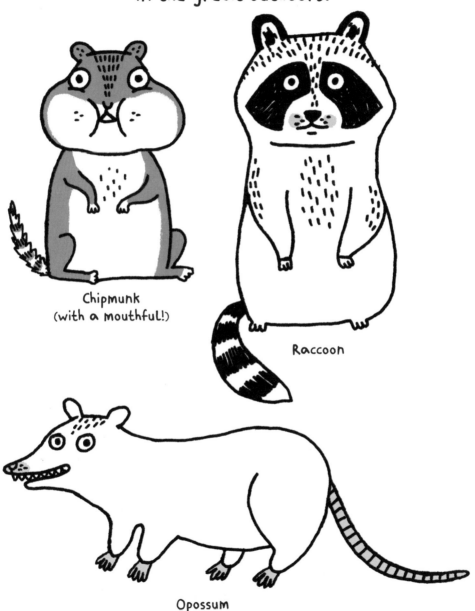

Chipmunk
(with a mouthful!)

Raccoon

Opossum

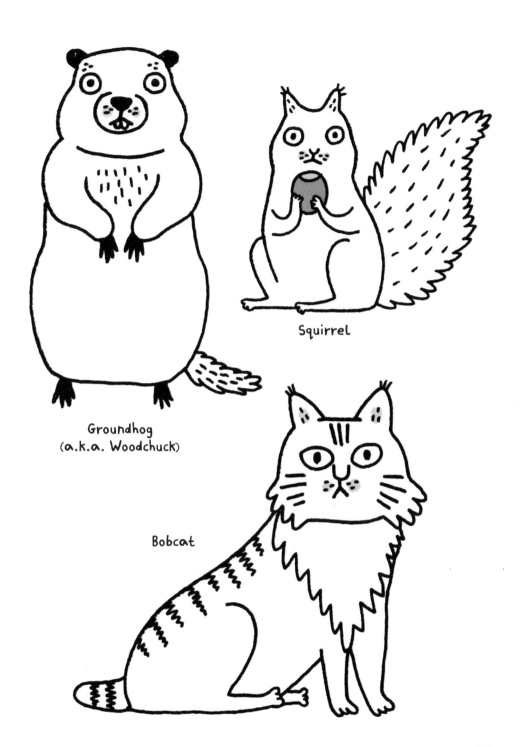

Squirrel

Groundhog
(a.k.a. Woodchuck)

Bobcat

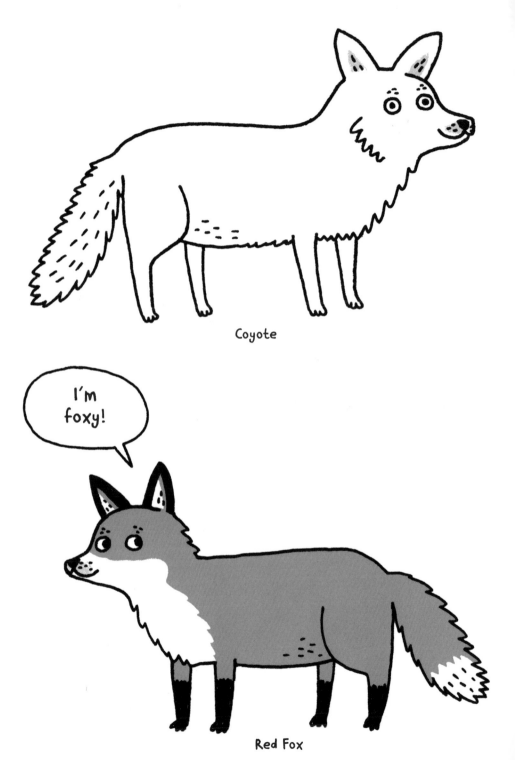

Coyote

I'm foxy!

Red Fox

GRIZZLY BEAR VS. BLACK BEAR
SPOT THE DIFFERENCE!

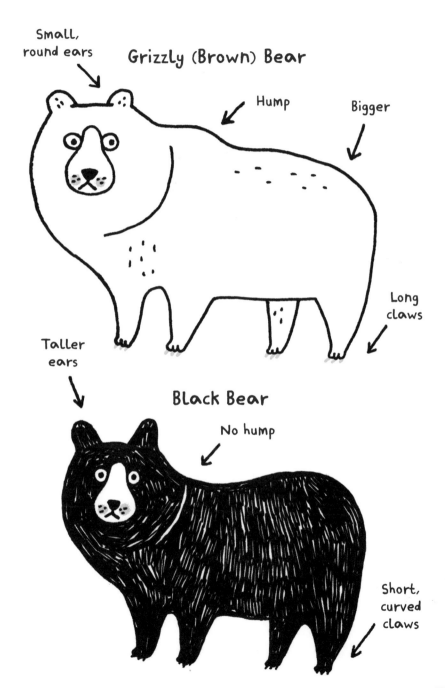

Small, round ears

Grizzly (Brown) Bear

Hump

Bigger

Taller ears

Long claws

Black Bear

No hump

Short, curved claws

ANIMAL TRACKS

Doodle and label tracks that you see
on the hiking trail.

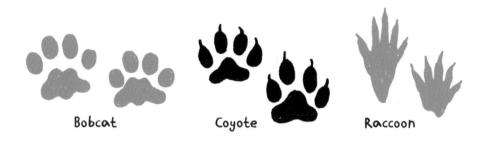

Bobcat Coyote Raccoon

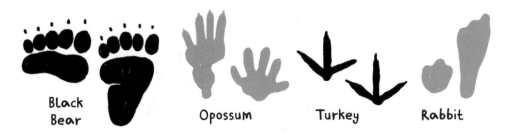

Black
Bear Opossum Turkey Rabbit

Otter

Red Fox

Deer

Lynx

Wild Hog

Yeti (???)

BEAUTIFUL BIRDS

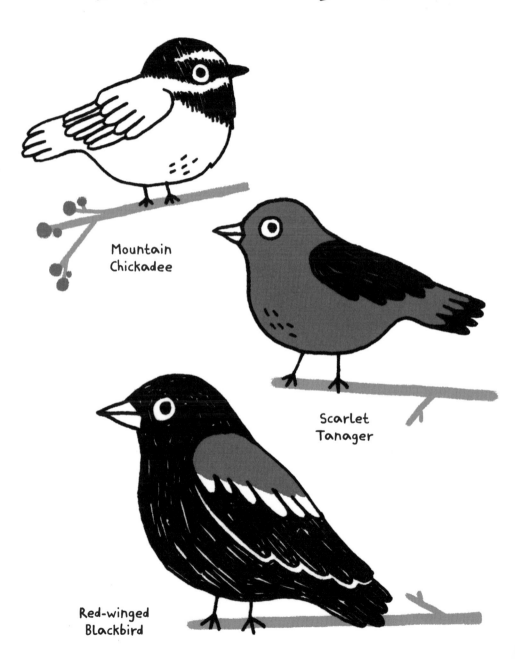

Mountain
Chickadee

Scarlet
Tanager

Red-winged
Blackbird

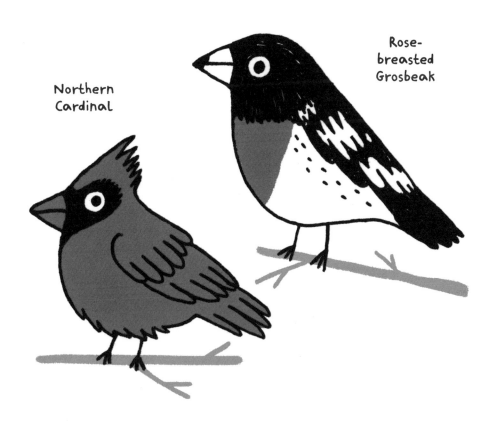

Northern
Cardinal

Rose-
breasted
Grosbeak

Draw a bird on this branch!

FANCY FEATHERS

A feather's appearance and shape depends on which part of the bird it comes from. Here are a few pretty bird feathers you might find.

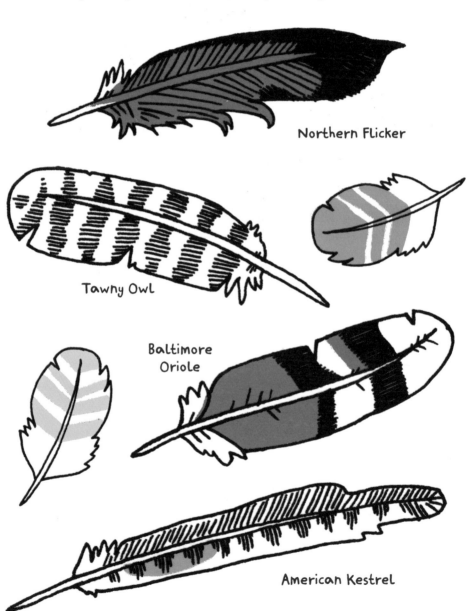

Northern Flicker

Tawny Owl

Baltimore
Oriole

American Kestrel

Doodle patterns on these feathers—real or imagined.

D.I.Y. BIRD FEEDERS

Cup & Saucer

Tin Can

What would you use to make a bird feeder? Doodle it here.

Humans are weird.

Old Shoe

80

Design a beautiful birdhouse
for a feathered friend.

WONDERFUL, WILD WORDS

Nature is always lovely, invincible, glad, whatever is done and suffered by her creatures. All scars she heals, whether in rocks or water or sky or hearts.

John Muir, *John of the Mountains: The Unpublished Journals of John Muir*

I am the lover of uncontained and immortal beauty. In the wilderness, I find something more dear and connate than in streets or villages. In the tranquil landscape, and especially in the distant line of the horizon, man beholds somewhat as beautiful as his own nature.

Ralph Waldo Emerson, *Nature*, Chapter 1

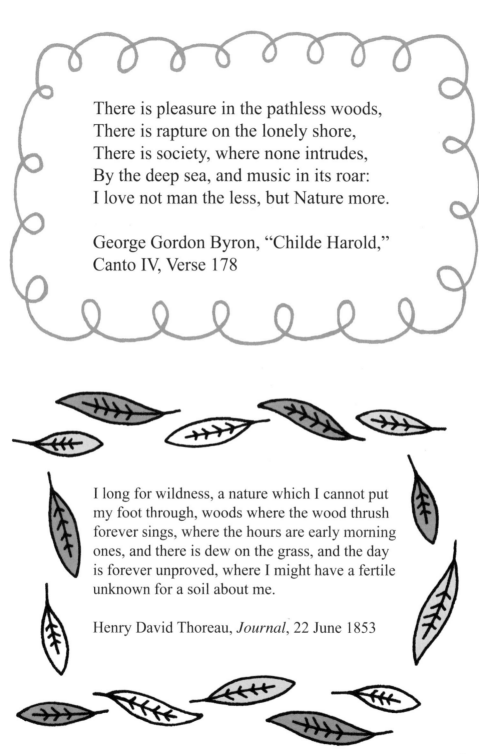

There is pleasure in the pathless woods,
There is rapture on the lonely shore,
There is society, where none intrudes,
By the deep sea, and music in its roar:
I love not man the less, but Nature more.

George Gordon Byron, "Childe Harold,"
Canto IV, Verse 178

I long for wildness, a nature which I cannot put
my foot through, woods where the wood thrush
forever sings, where the hours are early morning
ones, and there is dew on the grass, and the day
is forever unproved, where I might have a fertile
unknown for a soil about me.

Henry David Thoreau, *Journal*, 22 June 1853

SEASHELLS

These are just a few of the seashells that can be found on beaches all over the world.

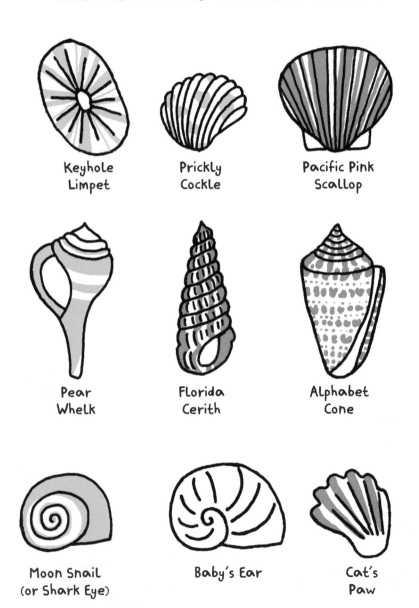

Keyhole
Limpet

Prickly
Cockle

Pacific Pink
Scallop

Pear
Whelk

Florida
Cerith

Alphabet
Cone

Moon Snail
(or Shark Eye)

Baby's Ear

Cat's
Paw

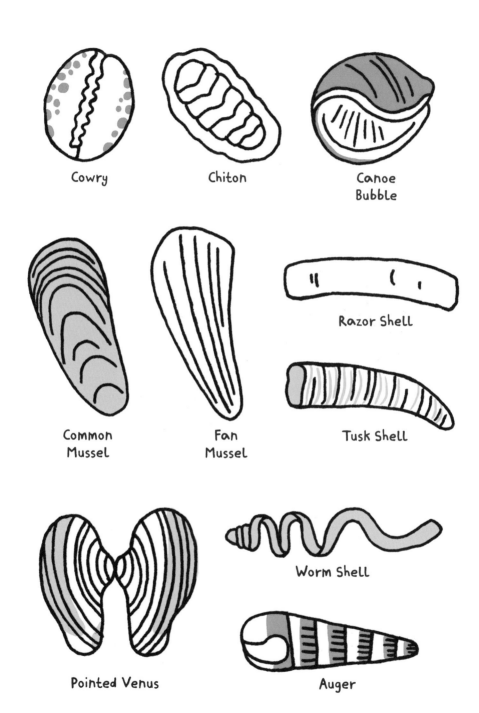

Cowry

Chiton

Canoe Bubble

Common Mussel

Fan Mussel

Razor Shell

Tusk Shell

Pointed Venus

Worm Shell

Auger

OTHER SEA CREATURES

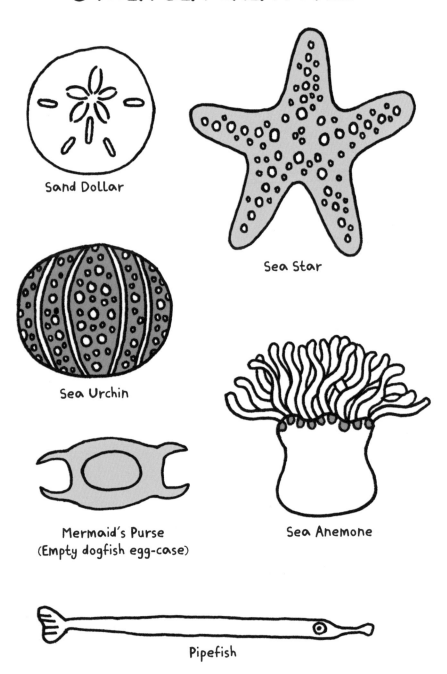

Sand Dollar

Sea Star

Sea Urchin

Mermaid's Purse
(Empty dogfish egg-case)

Sea Anemone

Pipefish

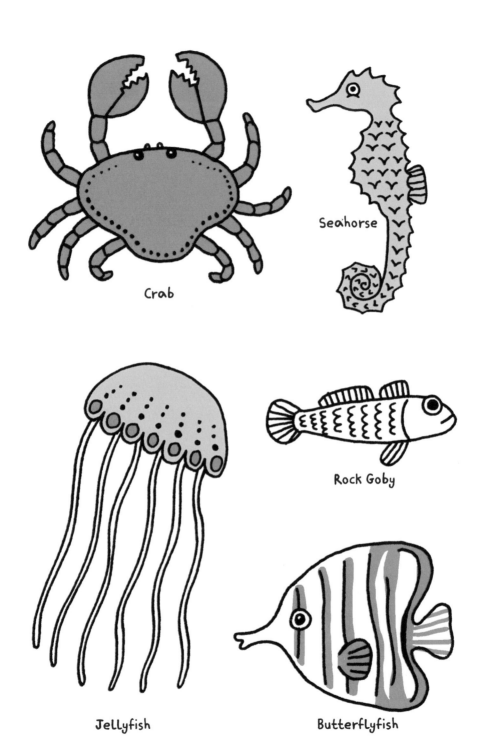

Crab

Seahorse

Rock Goby

Jellyfish

Butterflyfish

Fill these pages with doodled seashells and sea creatures.

DRAW A
SPECTACULAR SEAGULL

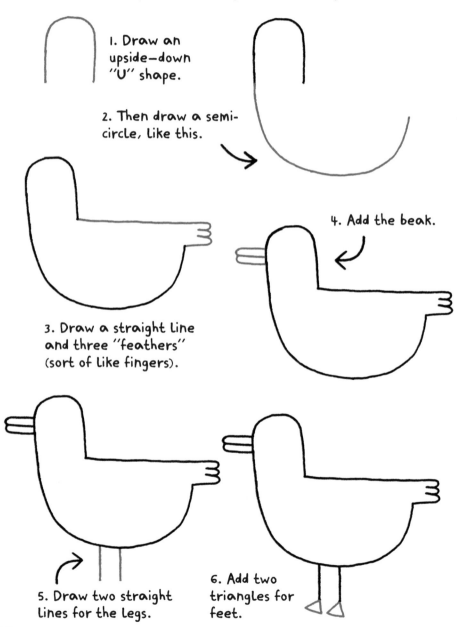

1. Draw an upside-down "U" shape.

2. Then draw a semi-circle, like this.

3. Draw a straight line and three "feathers" (sort of like fingers).

4. Add the beak.

5. Draw two straight lines for the legs.

6. Add two triangles for feet.

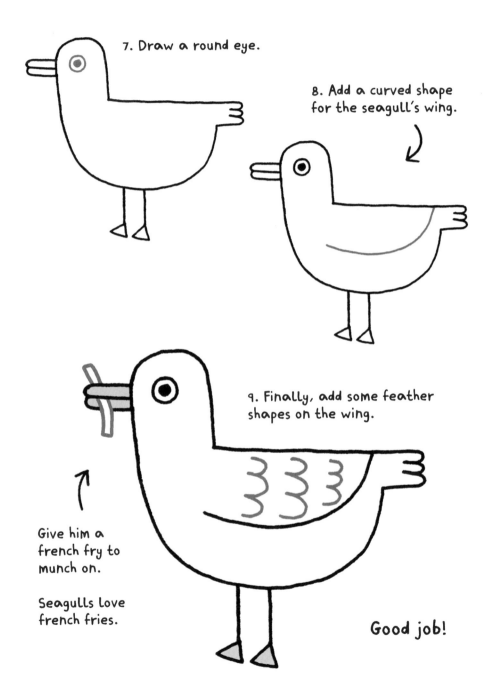

7. Draw a round eye.

8. Add a curved shape for the seagull's wing.

9. Finally, add some feather shapes on the wing.

Give him a french fry to munch on.

Seagulls love french fries.

Good job!

Draw your spectacular seagull here!

INCREDIBLE INSECTS
BEAUTIFUL BUTTERFLIES

California Dogface

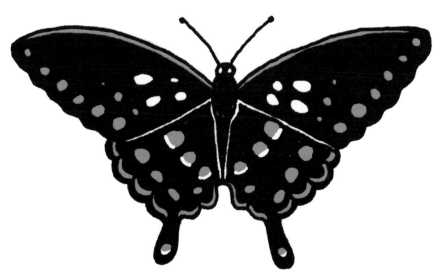

Spicebush Swallowtail

Draw the buckeye's other wing!

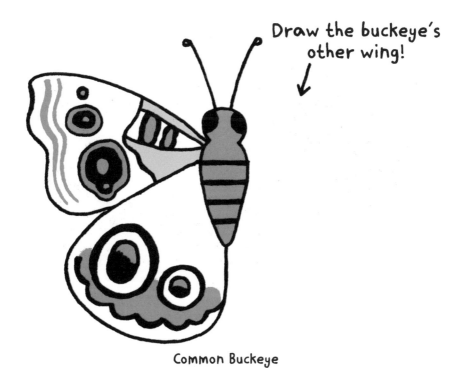

Common Buckeye

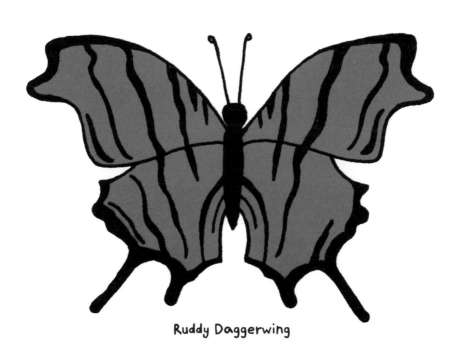

Ruddy Daggerwing

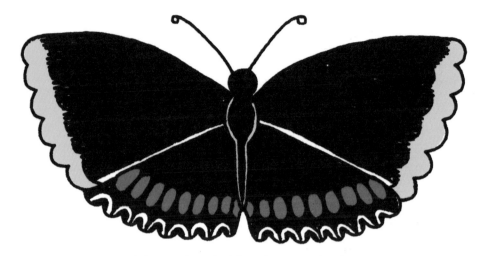

Crimson-banded Black (or Red) Rim

Draw the rest!
↓

Eastern Comma

Anna's Eighty-eight

Tiger Mimic-queen

DESIGNER BUTTERFLIES

Create and name your own kaleidoscope of butterfly species. ("Kaleidoscope" is the collective noun for a group of butterflies.)

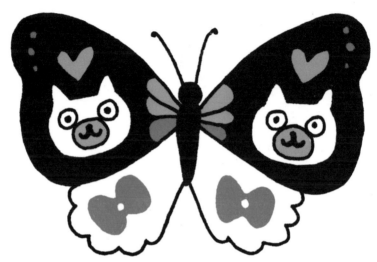

The Lesser-spotted Frilly-winged Kittenface

99

BUGS, BEETLES & SPIDERS...OH MY!

There are 350,000 known species of beetle in the world, but scientists believe that the real number is more like four to eight million! Like butterflies, beetles have varied and beautiful markings. Here are just a few.

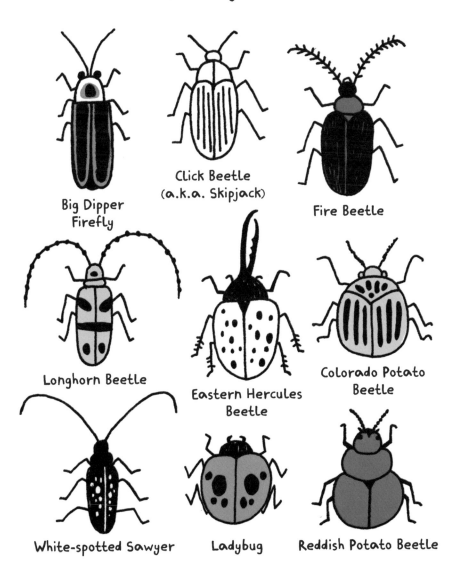

Big Dipper
Firefly

Click Beetle
(a.k.a. Skipjack)

Fire Beetle

Longhorn Beetle

Eastern Hercules
Beetle

Colorado Potato
Beetle

White-spotted Sawyer

Ladybug

Reddish Potato Beetle

Draw the markings of any beetles that you see out and about. Or invent your own (it could be one of the millions of as-yet undiscovered species!).

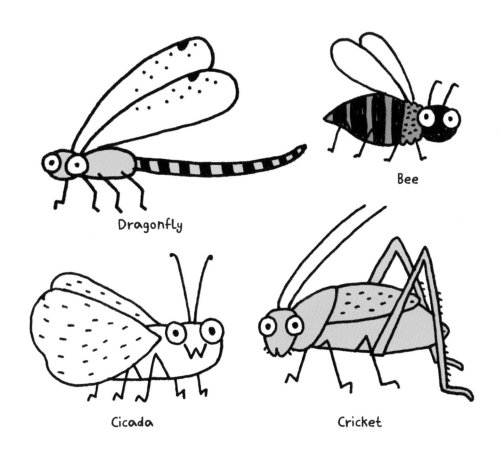

Dragonfly

Bee

Cicada

Cricket

Caterpillar

↑ Spotted any creepy crawly critters? Doodle them here.

SPIDERWEBS

There are a few different types of spiderwebs, including funnel webs, triangle webs, cobwebs (which are abandoned webs), and—probably the most recognizable—orb webs.

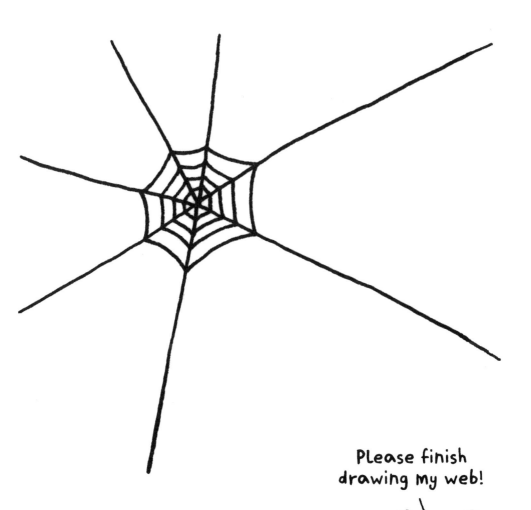

Please finish drawing my web!

NATURE IDIOMS

An idiom is an expression that can be understood from the meanings of the separate words but also has a separate meaning of its own. There are lots idioms based on nature. Here are just a few...

Can't see the forest for the trees
What it means: Someone is too engrossed in the details of a problem to look at the situation as a whole.

The apple doesn't fall far from the tree
What it means: Children are very similar to their parents.

Make hay while the sun shines
What it means: Make good use of the chance to do something while you have the opportunity.

A shallow brook babbles the loudest
What it means: Those who are loud and talk a lot usually have nothing of substance to say.

Older than the hills
What it means: Something or someone that is very, very old.

Up the river without a paddle
What it means: In an unfortunate situation.

Over the moon
What it means: To be very excited.

104

Can you finish these other nature-related idioms?
(Or make up your own silly versions!)

Caught between a _____ and a

_____ _____.

The _____ is always

_____ on the _____ side.

Make a _____ out of a

_____.

Answer the _____ of

_____.

B_____ around the _____.

NATURE GLOSSARY

Aiguille A needlelike rock mass or mountain peak

Anabranch A stream that branches off from a river and rejoins it further downstream

Ancient Forest A forest that is typically older than 200 years with large trees, dense canopies, and an abundance of diverse wildlife

Backcountry A sparsely populated rural region remote from a settled area

Bight A bend in a coast forming a bay

Bole The trunk of a tree, particularly the part below its branches

Bower A leafy shelter or recess

Conifers A group of trees and shrubs that produces cones; most are evergreens—trees that keep their leaves year-round

Copse A group of small trees growing very close together

Deciduous Falling off at the end of a growing period or stage of development

Dingle A small wooded valley

Ecotones The area where two adjacent ecosystems transition, such as woodlands to meadow

Estuary An area where a river flows into the sea

Fauna The animals of a specific region, considered as a whole

Fen Low land covered wholly or partly with water

Flora The plants of a specific region, considered as a whole

Floriography The language of flowers; a means of cryptologic communication through the use or arrangement of flowers

Frondescence The process of putting forth leaves

Greened Covered with herbage or foliage

Herbaceous Having the characteristics of an herb (e.g. the texture, color or appearance of a leaf)

Hillock A small hill

Hog-back A long, sharply crested ridge

Krummholz A forest of stunted trees near the timber line on a mountain

Lea Meadow grassland

Massif A compact portion of a mountain range containing one or more summits

Psithurism The sound of rustling leaves

Rill A very small brook

Scree An area of loose stones on the side of a mountain

Spinney A small wood with undergrowth

Symbiosis The relationship between two different kinds of living things that live together and depend on each other

Sylvan One that frequents groves or woods

Sward The grassy surface of land

Tarn A small lake among mountains

Tussock A small area covered with long thick grass

Umbel A flat-topped or ball-shaped flower cluster with individual flower stalks all growing from the same point on the stem, like the ribs of an umbrella

Vernal Of, relating to, or occurring in the spring

Wold An area of hilly land in the country

Zenith Highest point

DRAW A FABULOUS FLYING BAT

1. Begin by drawing a slightly squashed circle.

2. Then add two big triangles for ears.

3. Draw the face.

Two circles for eyes, a triangular nose, and a mouth with little fangs

4. Draw two curved lines at the bottom of the head.

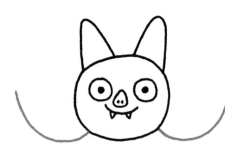

5. Then add two diagonal lines, like this.

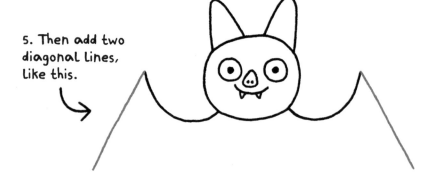

6. Draw four semi-circles (or two "M" shapes) to complete the wings.

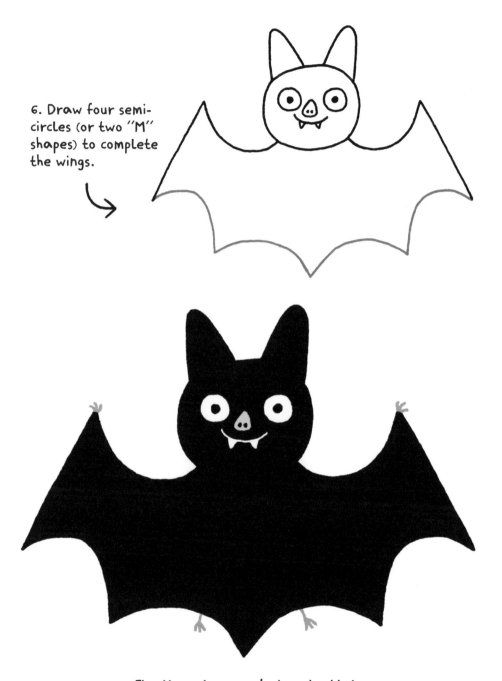

7. Finally, color your bat and add claws. Good job!

Draw your fabulous bat here!

ROCKIN' PAINTED ROCKS

You will need:

Paint pens or
acrylic paints

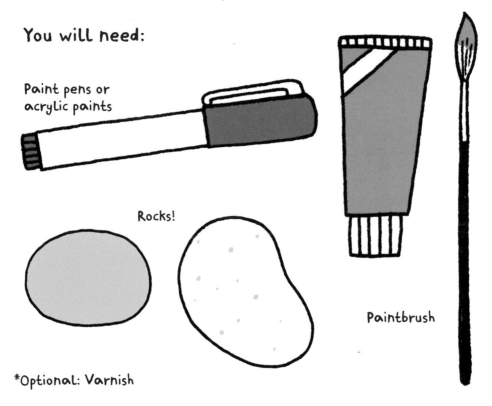

Rocks!

Paintbrush

*Optional: Varnish

INSTRUCTIONS

1. Collect your rocks. Try to find some interesting and varied shapes.

2. Clean and dry the rocks.

3. Paint your base color. You might need a couple of coats of paint for smooth color.

4. Make sure your base layer is dry before you paint the detail on top.

Hint: Use fine paint pens for smaller details.

5. If your rocks are going to be displayed outside, you might want to varnish them. Be sure to check that your paint is completely dry before varnishing.

Use the shape of the rocks to inspire what you paint on them.

How about some sweet strawberries?

...or brilliant birds?

Or, paint a couple of different shaped rocks and "plant" them in a pot to make a fun, no-maintenance cactus plant!

A DAY IN THE LIFE OF A CAMPER

From sunup to sundown, a day in the life of a camper is full of adventure, exploration, and observation in the great wide world.

4 AM — Awakened before dawn by a chorus of birds welcoming the new day

7 AM — Reawakened after dozing through the morning's symphony—awkwardly get dressed in the tent

8 AM — Sit around the morning campfire with tumblers of instant coffee and eggs, freshly scrambled fireside

8:30 AM — Pack for the day's adventures. Water? Check. Snacks? Check. Sunscreen? Check. Doodle book? Double-check.

9 AM — Off on a hike through the wonderful woods

9:30 AM — First wildlife spotting: a chipmunk!

10 AM — Break to hydrate, and snack on trail mix

10:15 AM	Back at it again, just in time for a second wildlife spotting: a deer!
11:30 AM	Break for lunch (beef jerky, apples, and more trail mix) by a crystal-clear lake
12 PM	Time for some doodling
1:15 PM	Just a little bit further to finish the hike...
2 PM	Final destination reached: a beautiful panoramic view of the woods and beyond
2:30 PM	No rest for this camper...back on the trail heading back toward camp
3:30 PM	Another wildlife spotting: A hawk!
4 PM	Quick break for some cookies before making the final push
5 PM	Arrive back at camp, tired yet refreshed all at once!
6 PM	Roast hot dogs and marshmallows over the campfire
8 PM	Sing songs, tell stories, and make general merriment
9:30 PM	Tucked in sleeping bag, listening to the crickets, ready to do it all over again tomorrow...

CURIOUS CONSTELLATIONS

There are currently 88 constellations recognized by the International Astronomical Union. Here are a few to look for in the night sky.

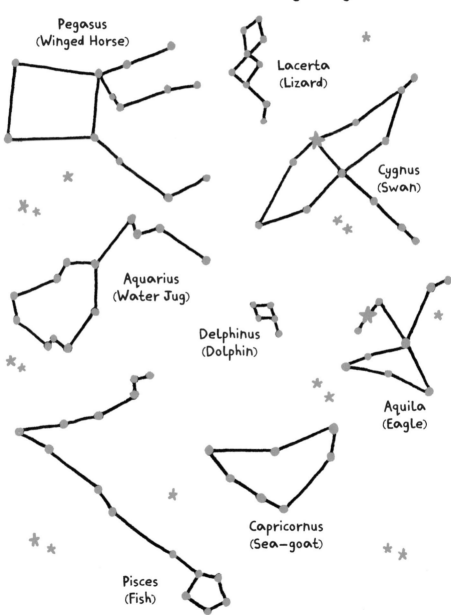

Pegasus
(Winged Horse)

Lacerta
(Lizard)

Cygnus
(Swan)

Aquarius
(Water Jug)

Delphinus
(Dolphin)

Aquila
(Eagle)

Capricornus
(Sea-goat)

Pisces
(Fish)

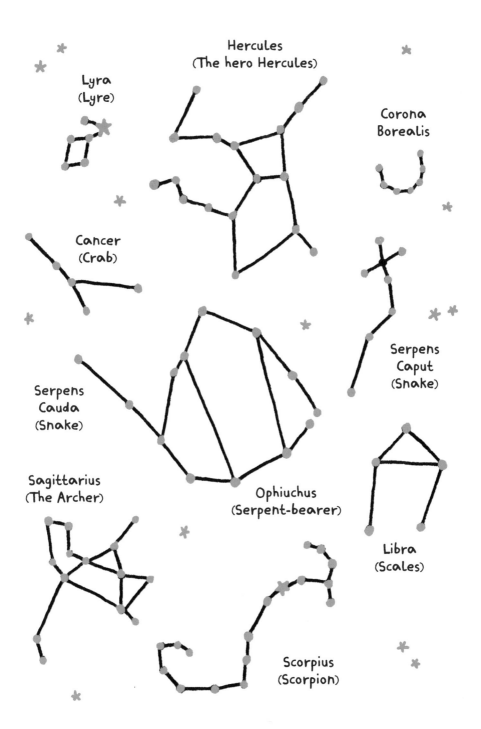

Lyra
(Lyre)

Hercules
(The hero Hercules)

Corona
Borealis

Cancer
(Crab)

Serpens
Caput
(Snake)

Serpens
Cauda
(Snake)

Ophiuchus
(Serpent-bearer)

Sagittarius
(The Archer)

Libra
(Scales)

Scorpius
(Scorpion)

CREATE YOUR OWN CONSTELLATIONS

Design and name your own constellations.

Here's mine!

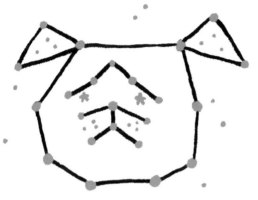

Canis Pugnus Majoris
(The Pug)

COOL CLOUD FORMATIONS

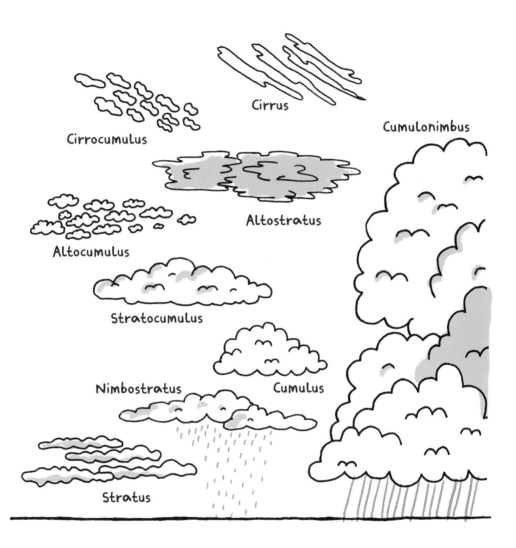

What's your favorite kind of cloud?

Draw the clouds you see in the sky.
Do they remind you of anything?

Bunnocumulus
(Watch out for the
precipitation!)

DOODLE DIARY

Use these pages to doodle all your favorite things in nature, from animals and plants to your favorite outdoor gear!

ABOUT THE ILLUSTRATOR

Gemma Correll is a cartoonist, writer, illustrator, and all-around small person. She is the author of *A Cat's Life, A Pug's Guide to Etiquette,* and *It's a Punderful Life,* among others. Her illustration clients include Hallmark, *The New York Times,* Oxford University Press, Knock Knock, Chronicle Books, and *The Observer.* Visit www.gemmacorrell.com to see more of Gemma's work.